Old Dogs

Sally Muir

PAVILION

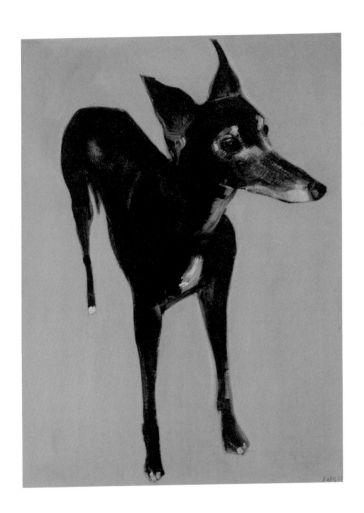

Everyone loves a puppy, but there is something infinitely touching about the grey muzzle, milky eyes and wobbly legs of the older dog that really tugs at the heartstrings. There is also the shared life, the years spent getting to know one another and understanding each other's little ways.

When I started this project I put out a call on social media for people to send me photographs of their old dogs, and I got hundreds. They were wonderful and often came with heartfelt and heartbreaking descriptions of the dog, notes on how much their owner loved and appreciated them, and quite detailed accounts of their canine idiosyncrasies. It was a struggle choosing which ones to paint. I'd like to thank everybody who sent me photographs, and if I haven't been able to include them, I'm really very sorry, I would have included absolutely all of them if I could, but I just couldn't fit them all in.

My whippet, Lily, is now 14, and is the longest-living dog I've ever had — we've grown grey together. As she's got older, I've come to appreciate the joy of the senior dog. We've come to understand each other's language — if she were human, we'd definitely be finishing each other's sentences. Apart from the

thickening waist and cloudy eyes, Lily is now quite shaky on her legs, but she still valiantly follows me from room to room and up and down the stairs all day, as well as just standing next to me and occasionally poking me gently in the leg to reassure me that she's there. Or to reassure herself that I'm there, who knows?

Like elderly humans, she has become a slightly more exaggerated and uninhibited version of her younger self. She's always been a thief but will now steal blatantly and entirely without guilt. She's also quite averse to going out in the cold or wet and has been known to pee on the carpet while steadily looking you in the eye. And now, more than ever, she loves a routine. At the same time every evening she hauls herself off the sofa — where she sleeps with her chin on my leg to prevent my escape — and flings herself onto the carpet for a slow and stately back scratch, before her nighttime snack.

Lily won't be with me for much longer so this book, which has taken five years to put together, is a tribute and celebration of her and of all old dogs and their owners who love and appreciate them in all their grey, smelly, lumpy, opinionated glory.

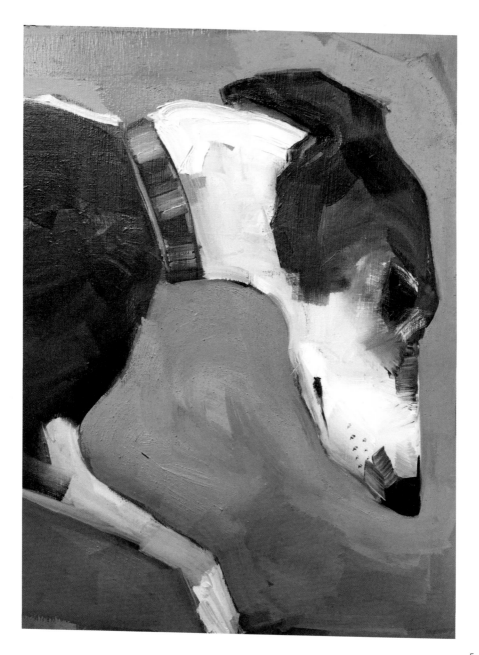

5

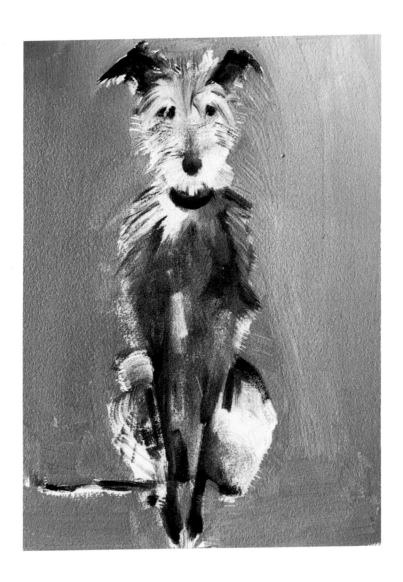

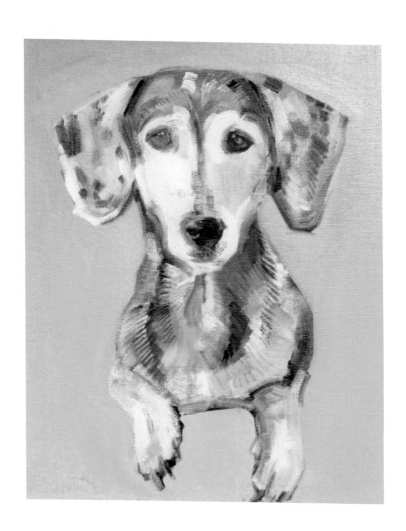

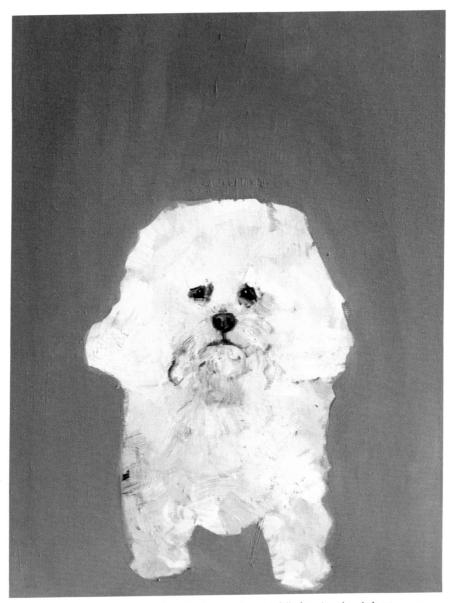

Betty, rescue Bichon, went through a lot in her former life and is full of anxiety, but she's a trooper

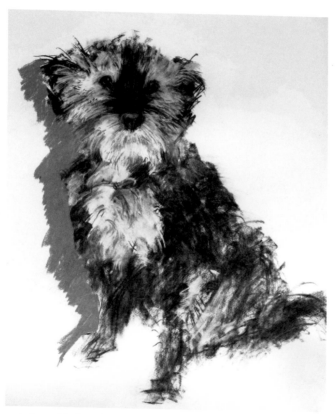

Ambrose, 'the best dog ever' – charming, brainy, independent and loving

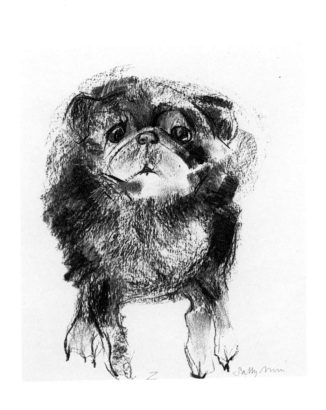

10

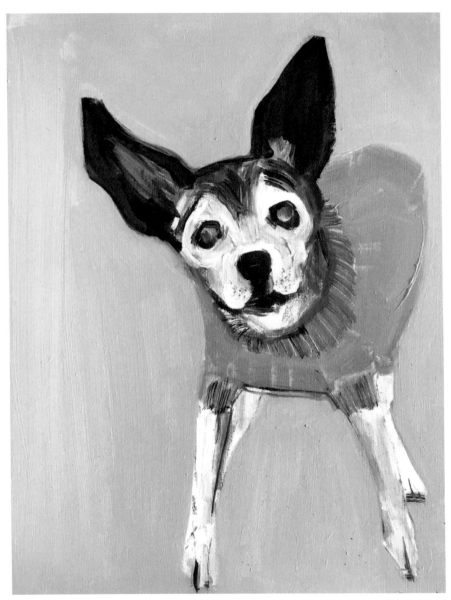

Wobbly Walter, a big character in a tiny body

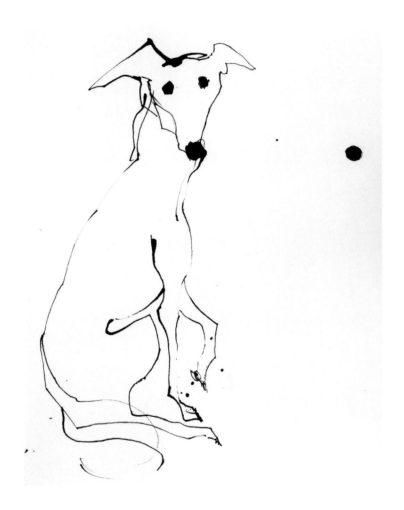

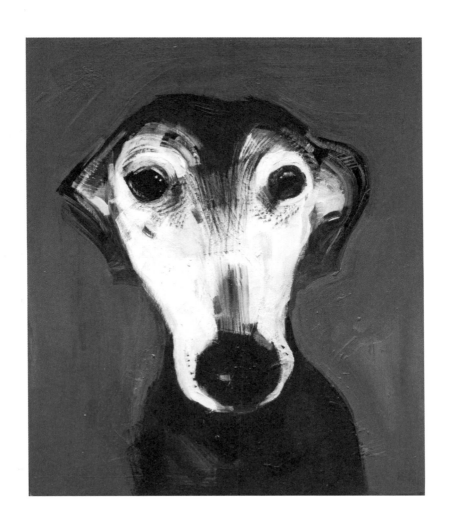

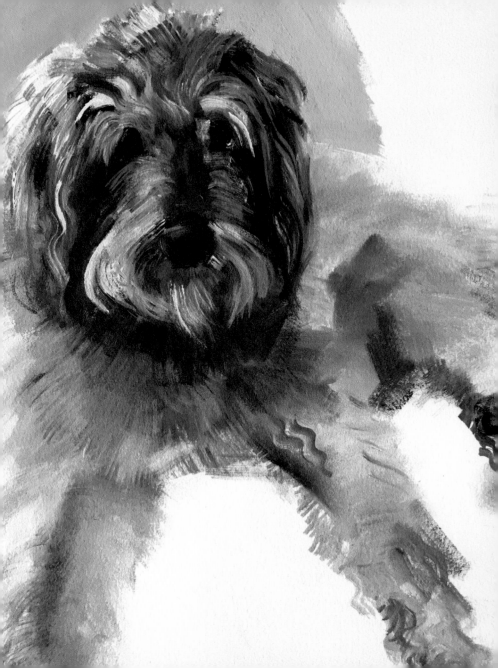

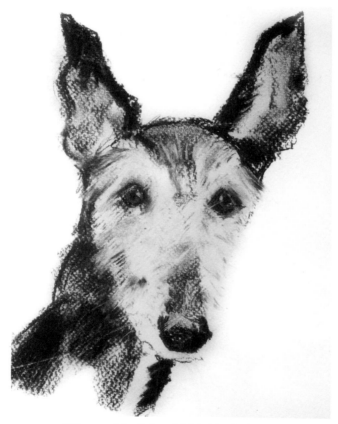

Odin, one of the Galgos del Sol oldies; he loved a bum scratch
and had his own armchair in the Spanish home for retired galgos

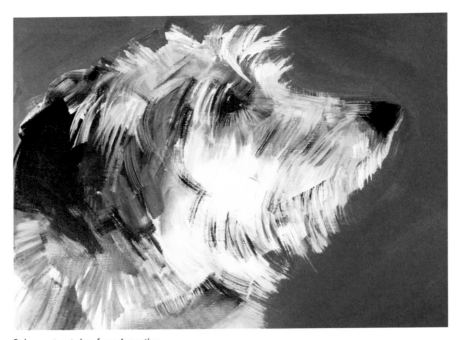

Beba, a street dog from Argentina

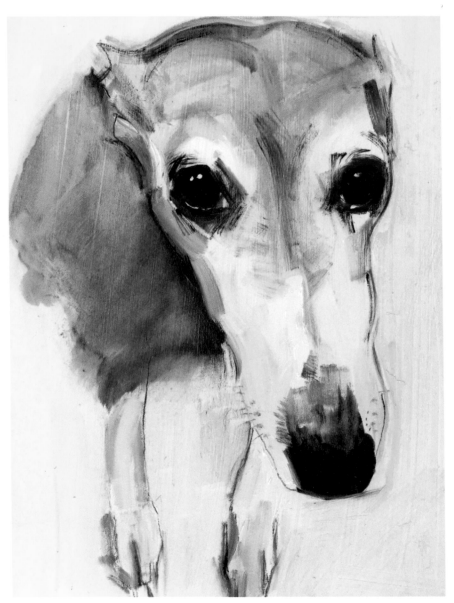

Lily, looking more miserable than she actually is – she doesn't like wearing a coat

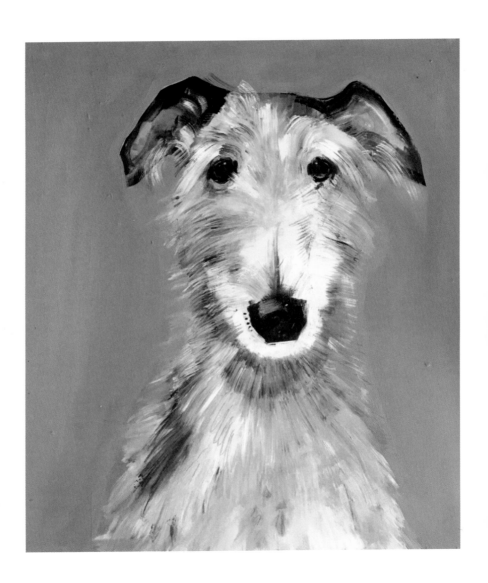

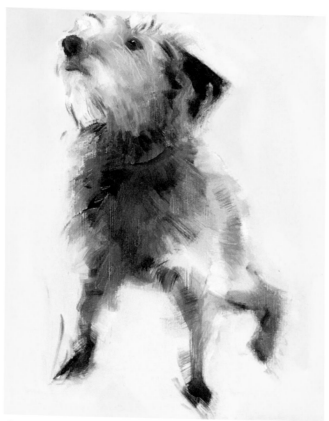

Connie, princess and great friend to my girls, has the best eyebrows in Bath

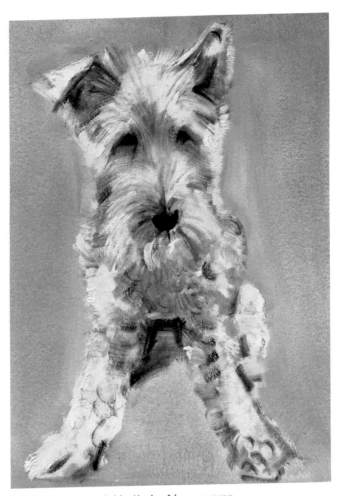

Alfie Rae Razamataz Bobby Haylor, 16 years young

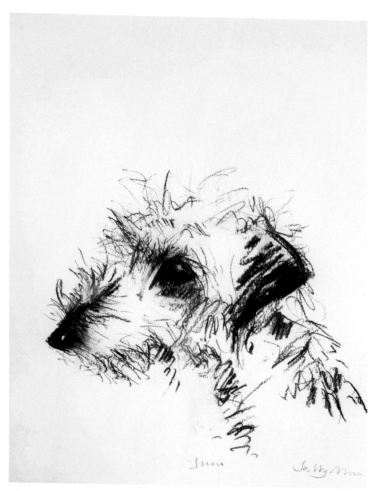

Tiny old Bedlington, completely bald tail

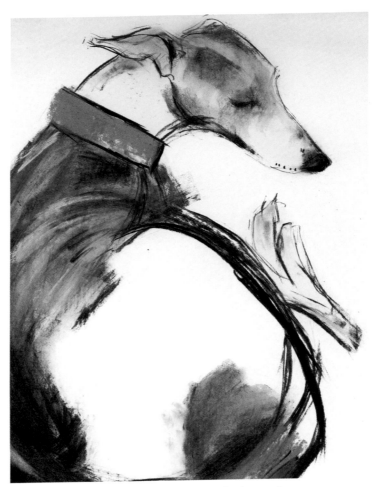

Lily, serene and gorgeous, aged 14 – possibly not her best angle

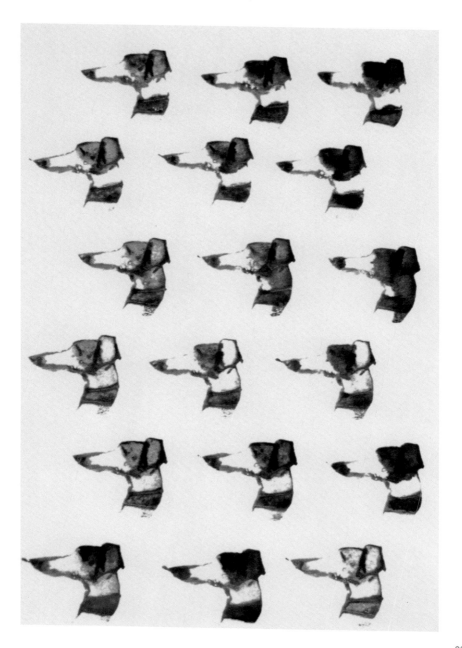

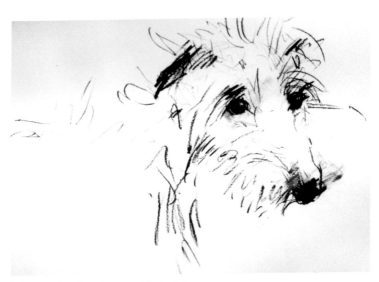

15-minute drawing of a very elderly dog

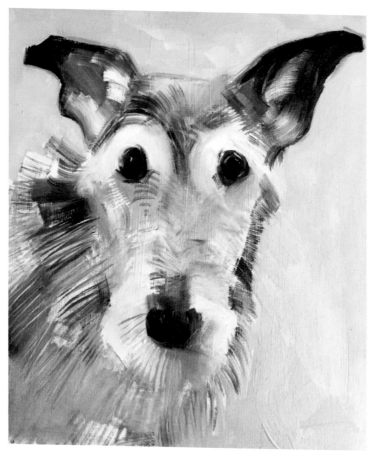

Jet, beautiful aged lurcher – a dream subject

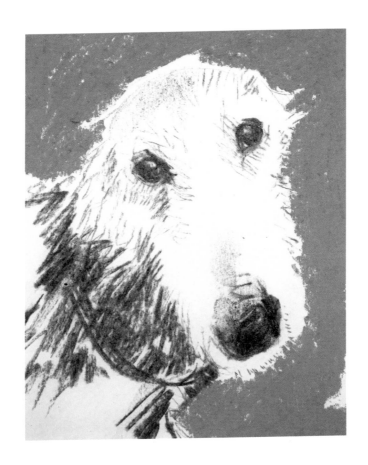

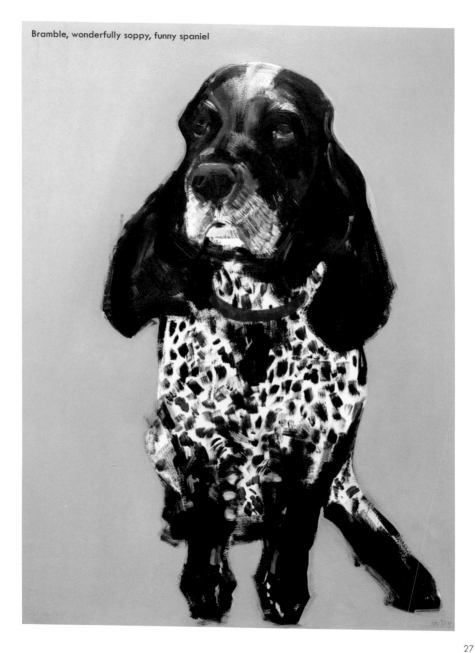

Bramble, wonderfully soppy, funny spaniel

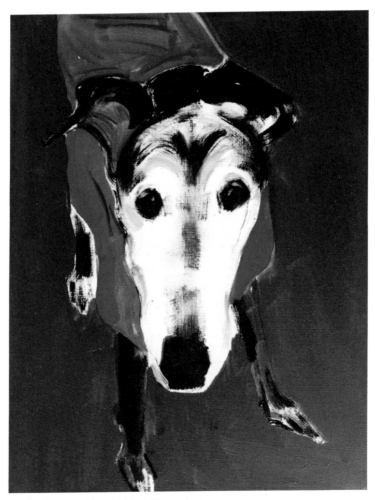

Norris, 13 years old and a bit wobbly on his legs

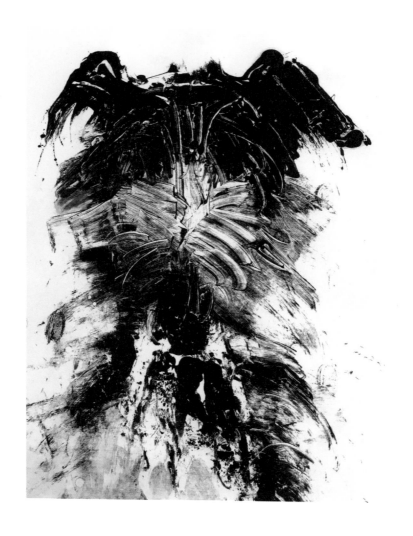

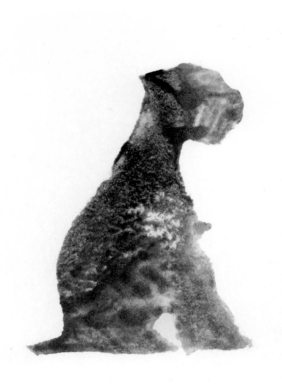

Curly the miniature schnauzer in potato print form

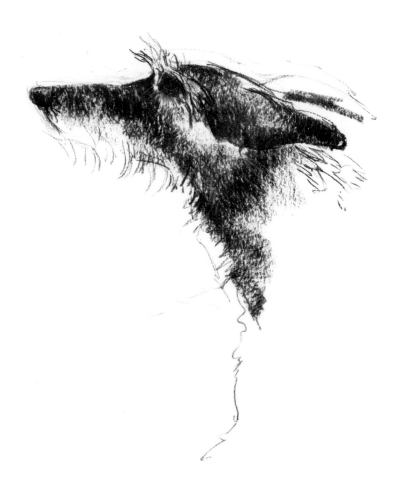

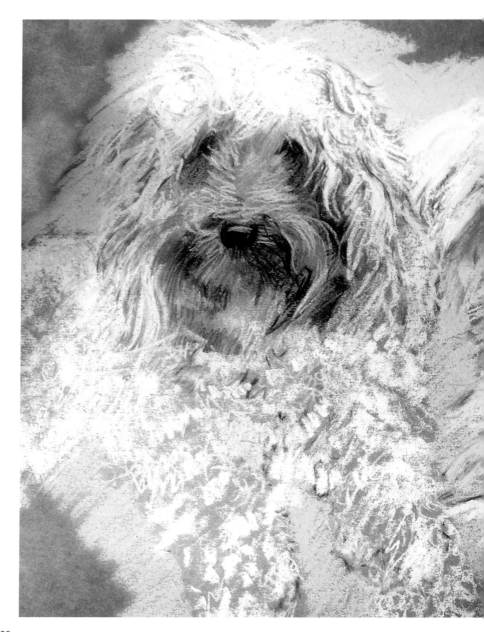

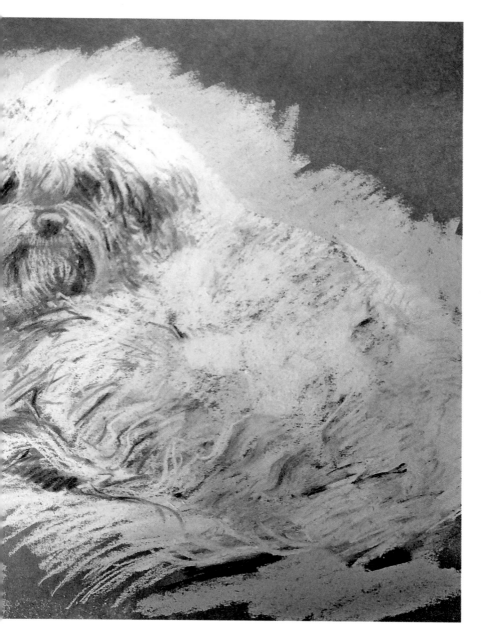

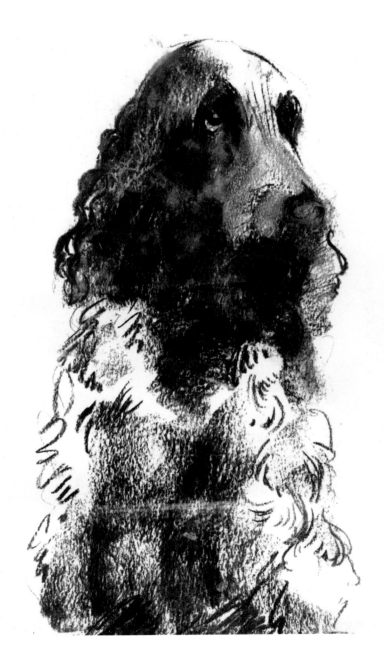

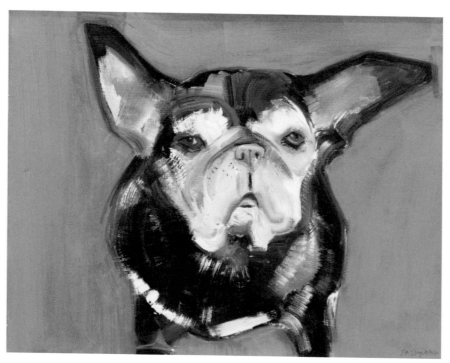

Alouette, 13 years old and described by her owner as 'resembling Yoda'

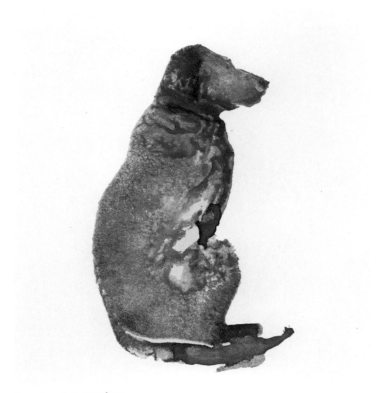

Barry in potato print form

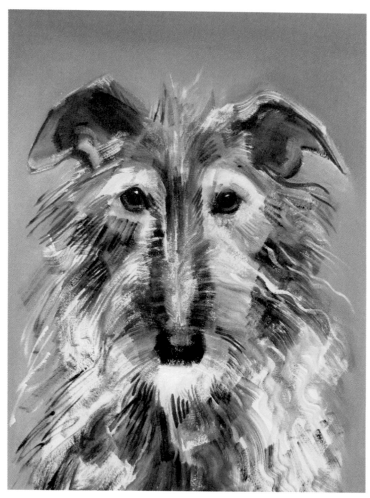

Rosendo Rockstar, amazingly charismatic rescued
galgo from Toledo, now living happily in Chicago

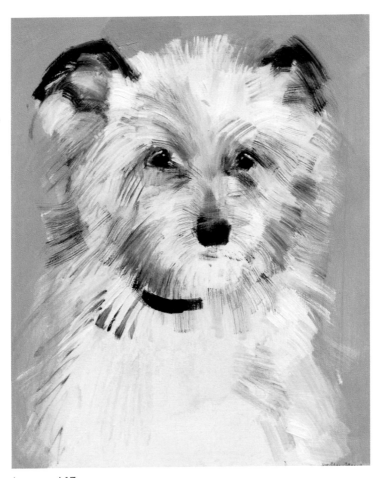

Jenny aged 17

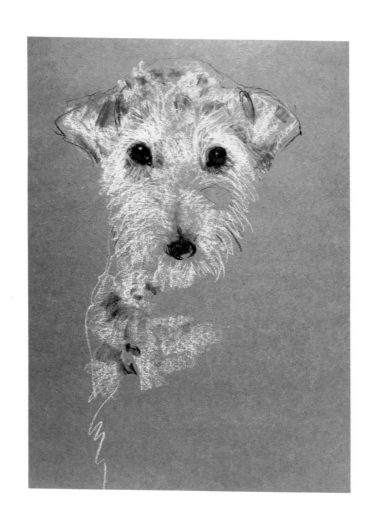

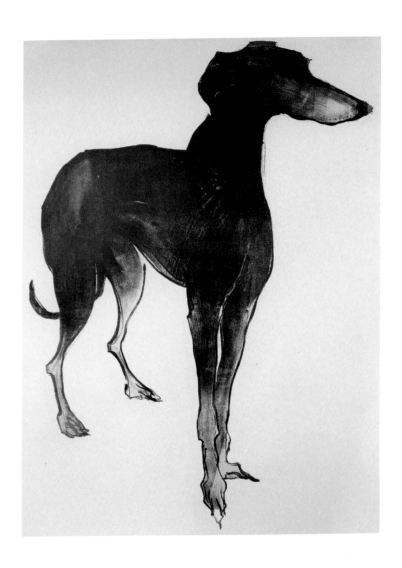

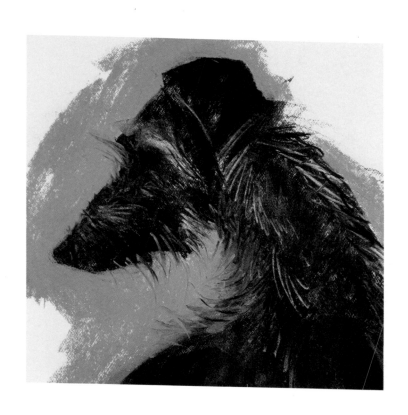

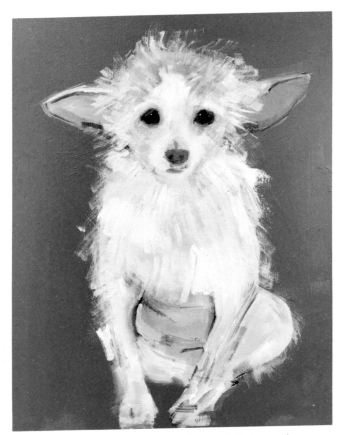

Susie of Susie's Senior Dogs; adopted at the age of 11 she was the inspiration behind an organization promoting the adoption of older dogs

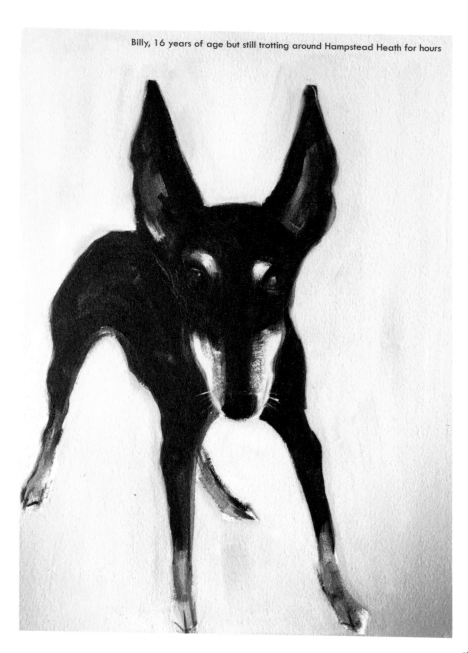

Billy, 16 years of age but still trotting around Hampstead Heath for hours

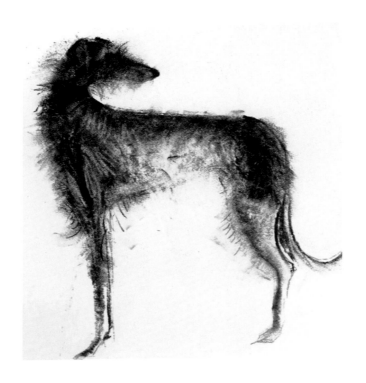

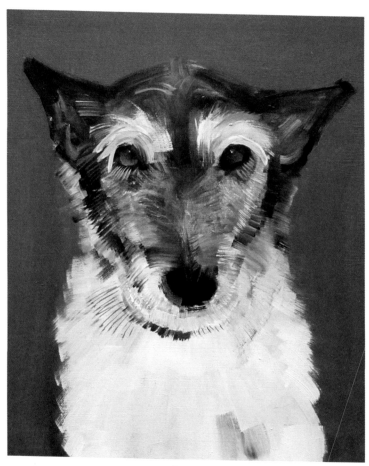

Dyzio, who still hasn't figured out how to bark

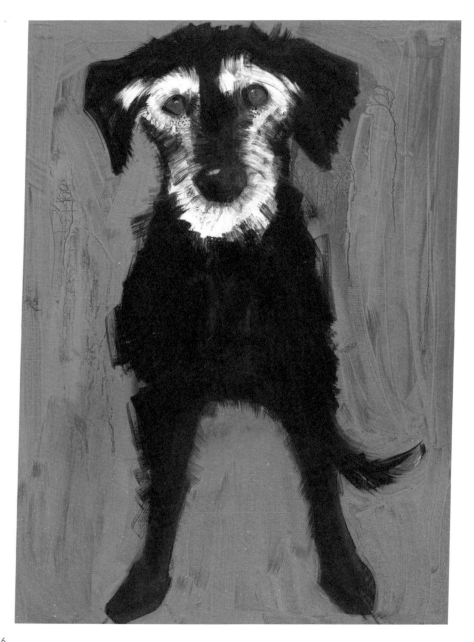

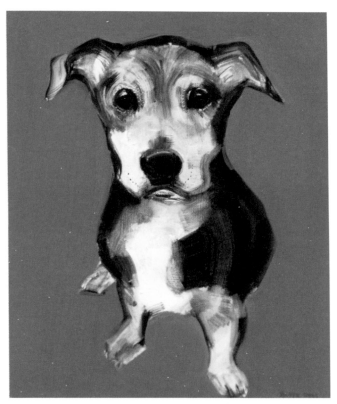

Mr. Moo, gorgeous Staffie-Jack Russell cross, very winning expression

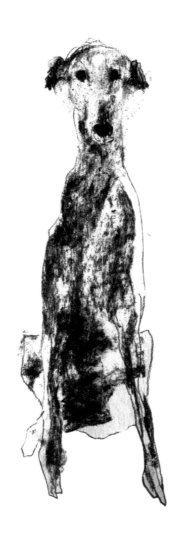

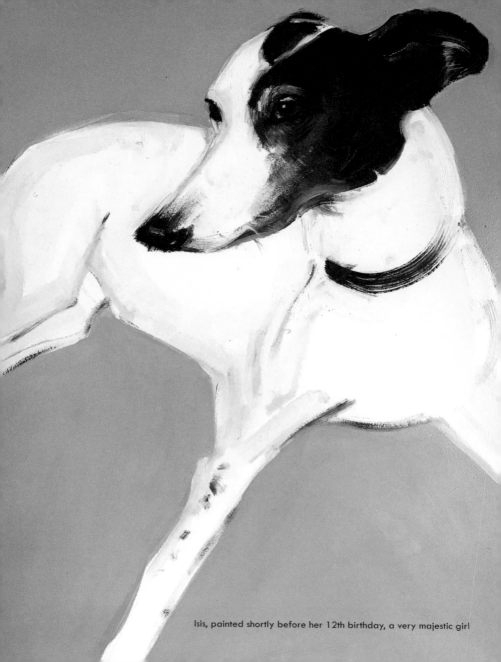

Isis, painted shortly before her 12th birthday, a very majestic girl

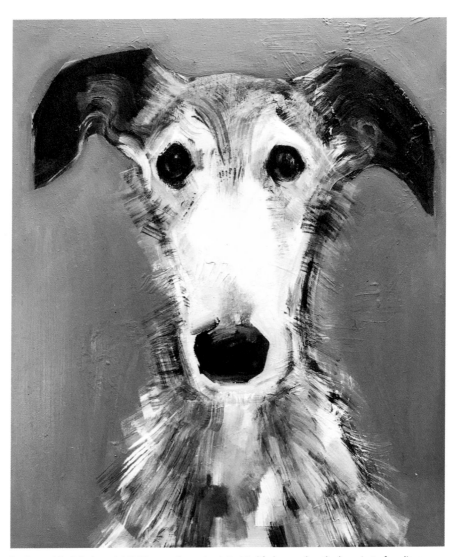

Declan, a blind Galgos del Sol boy — after a bad start in life he now has the happiest of endings

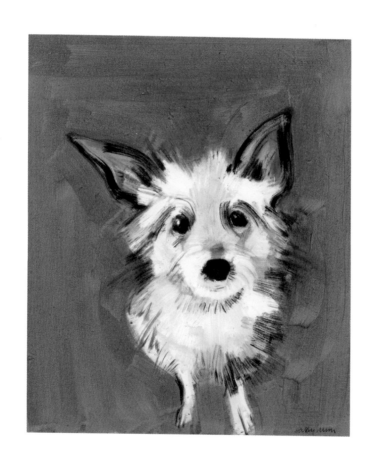

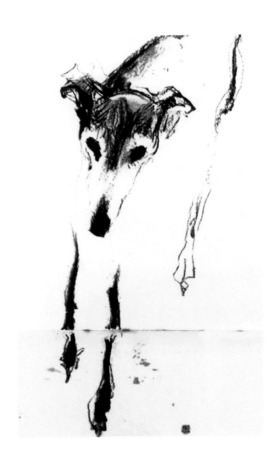

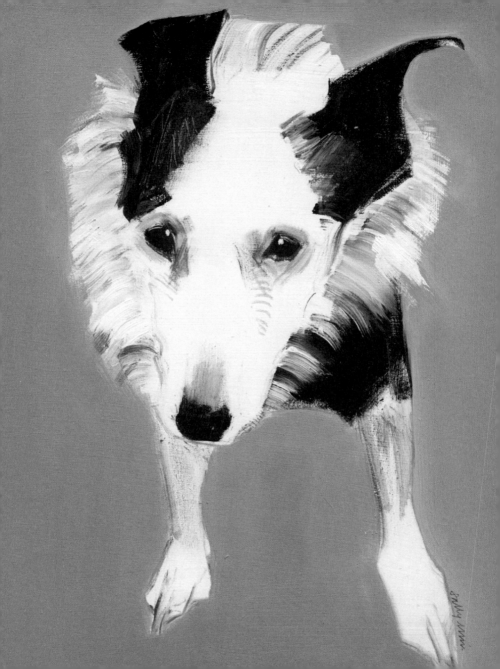

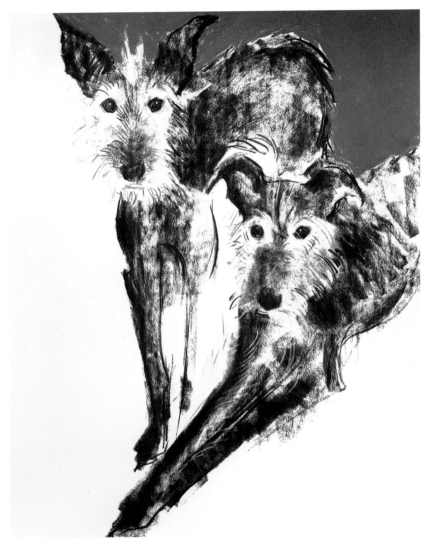

Alfie and Mac, 14-year-old brothers – Alfie is the life and soul of the party, Mac is more reserved.

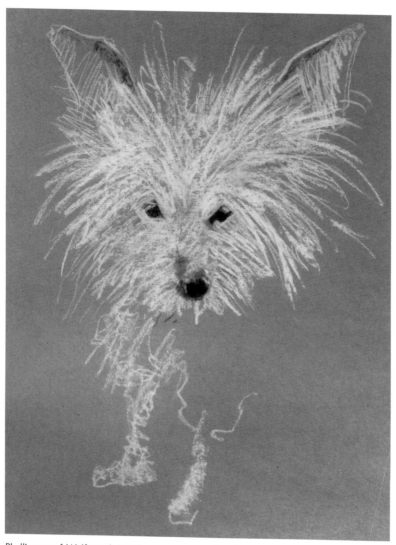

Phyllis, one of Wolfgang's Instafamous rescue pack, is full of confidence with a strong sense of belonging; rescued with no hair and little eyesight, she grew this magnificent mane

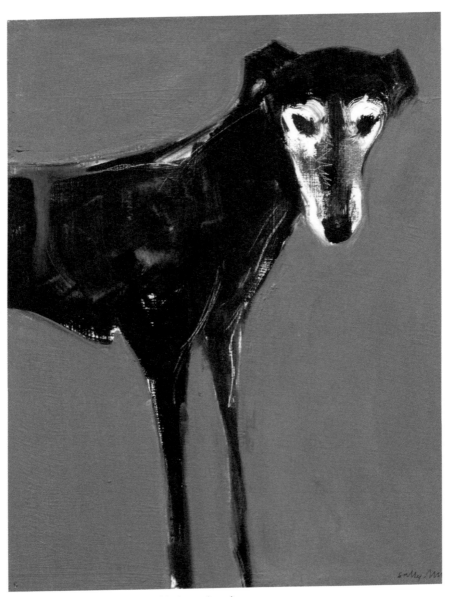

Aubrey, elegant and distinguished elderly greyhound

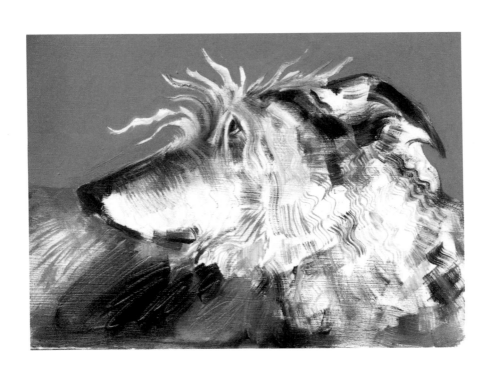

Edna is also owned by the legendary Wolfgang, a serial adopter of elderly dogs – he describes her as 'the brightest light in every room of the house'

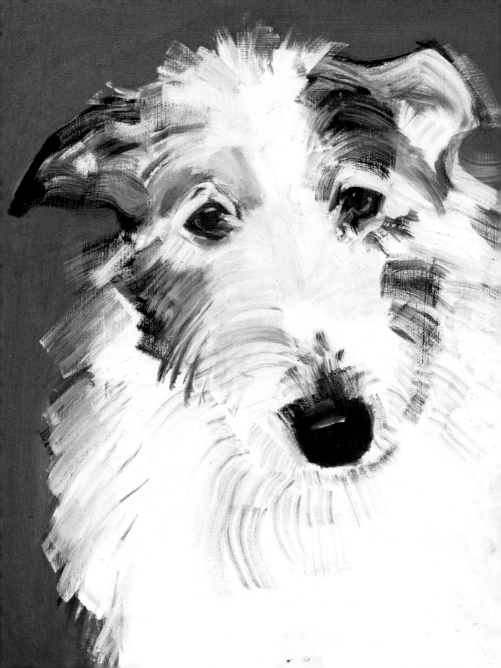

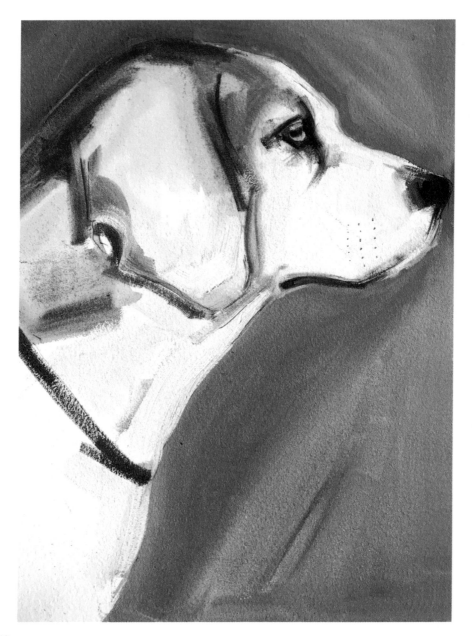

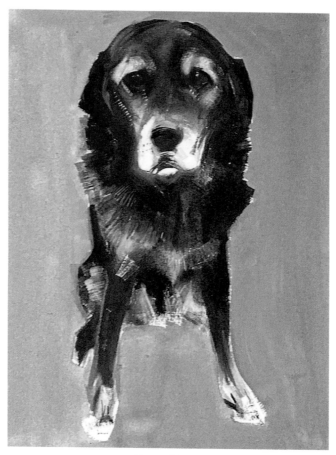

Above: Minnie, much loved by my friend Ewan
Opposite: Ruby, the ever regal beagle

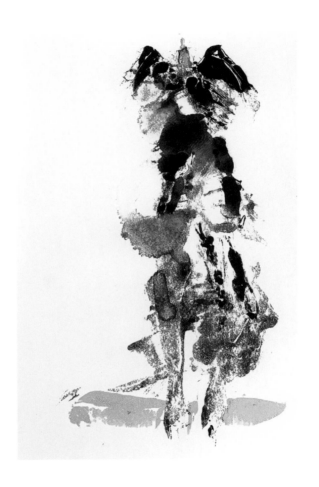

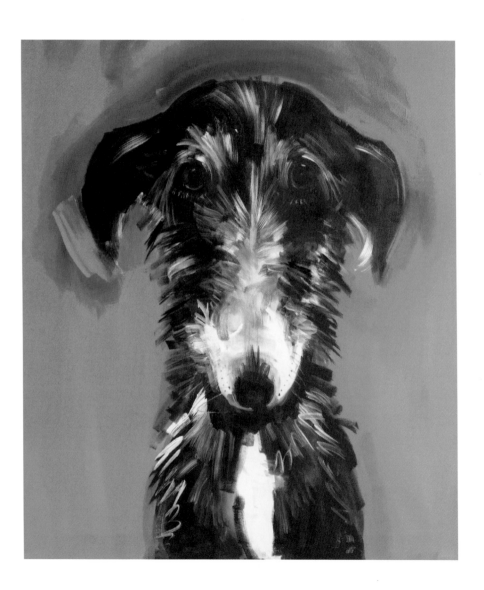

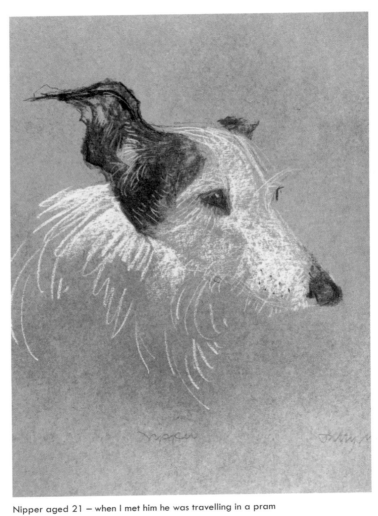

Nipper aged 21 — when I met him he was travelling in a pram

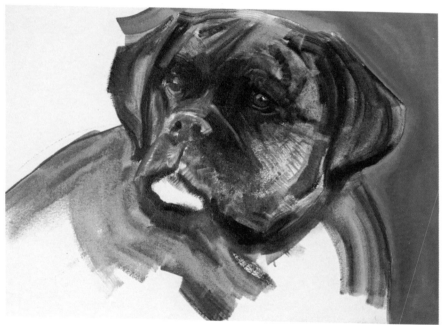

Sammy, calm, faithful and trusting, was known to happily enjoy a firework display

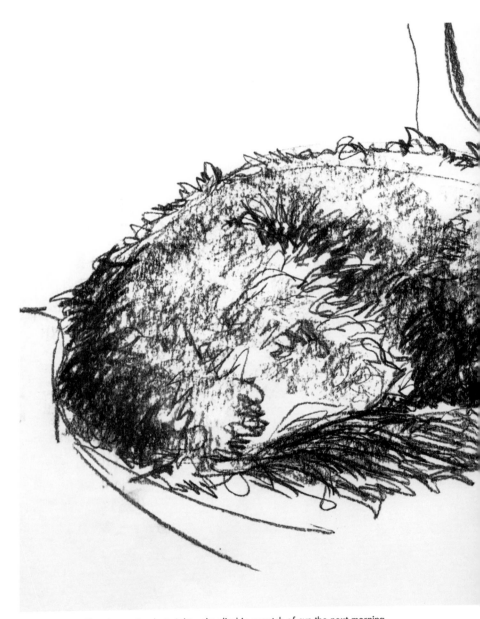

Fanny Muir, my first dog on her last night — she died in a patch of sun the next morning

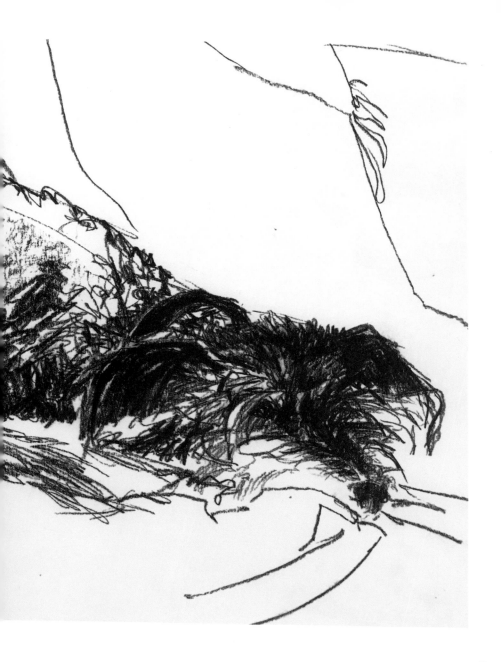

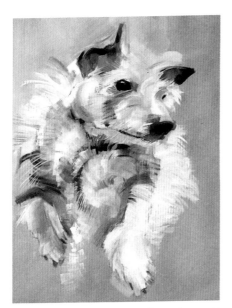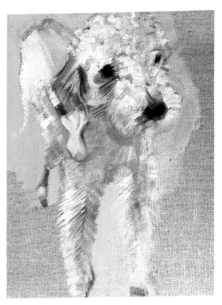

Left: Bess, an absolute trooper of a terrier, would walk for miles and miles
Right: Maddie the studio dog – loving, characterful and stubborn, with a brilliantly disapproving side eye

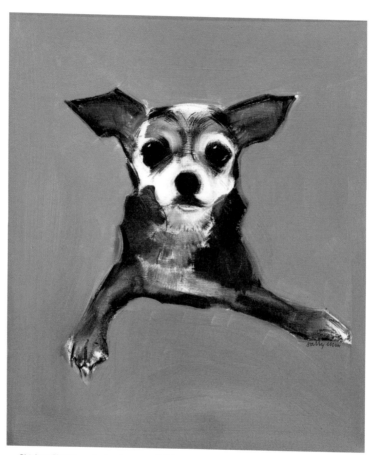

Shirley Chicken, gloriously named 14-year-old rescue 'Chug', a Chihuaua-pug mix

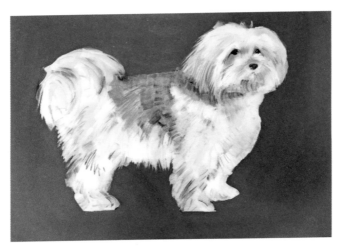

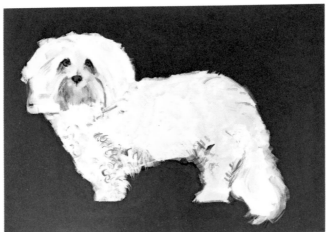

Top: Hettie, Havanese princess and a bit of a cheerleader
Bottom: Lewis 11-year-old Coton de Tulear, 'Mr Sedentary' – he is
either very wise or of very little brain

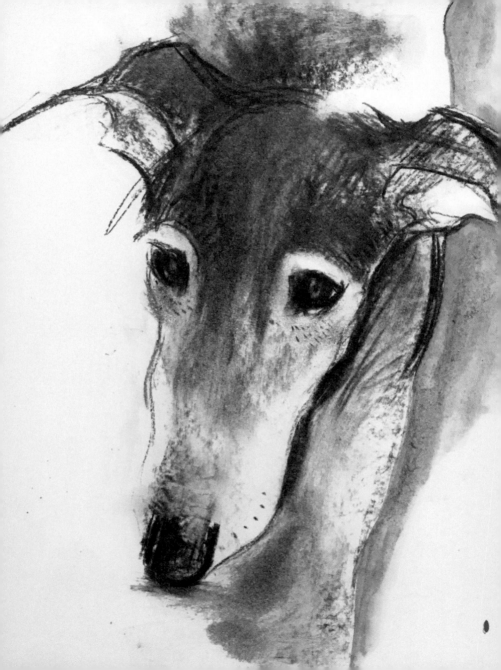

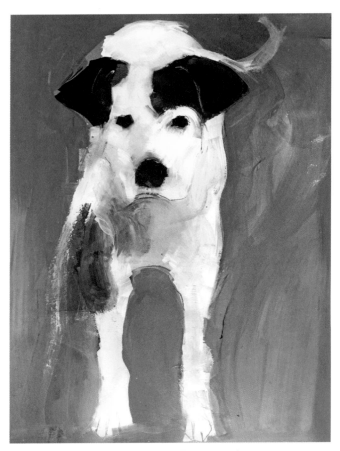

Dennis, Parson Jack Russell, here aged 17 – a great character

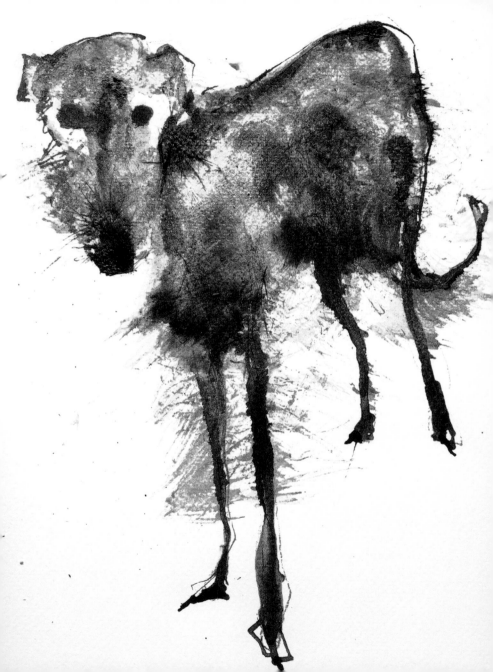

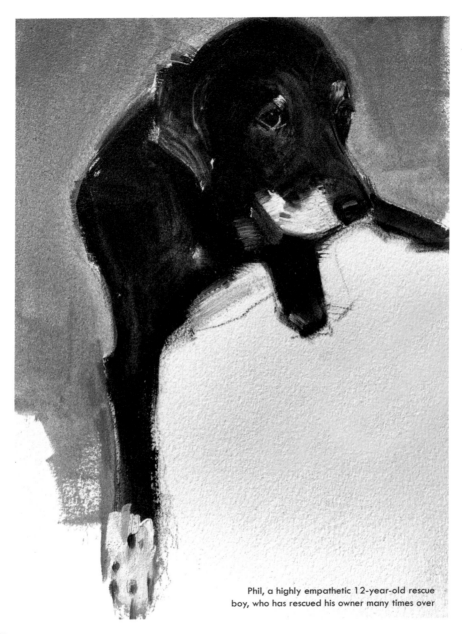

Phil, a highly empathetic 12-year-old rescue
boy, who has rescued his owner many times over

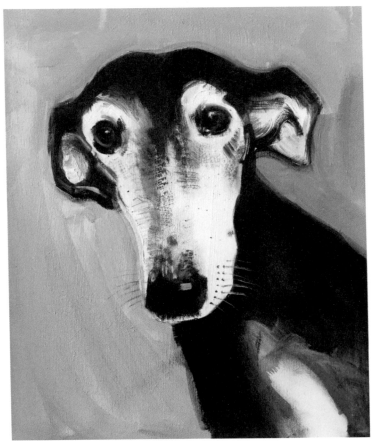

Tazi aged 13, lovely eyebrows and distinguished grey markings

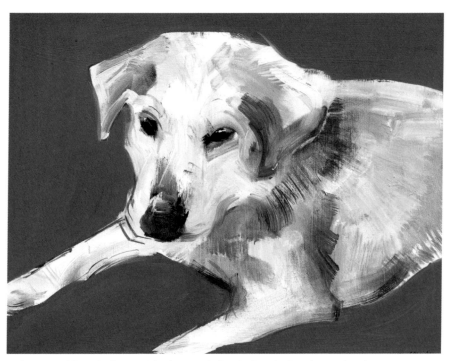

Kaibo, rescued from the Caymen Islands, named after the beach where he was found

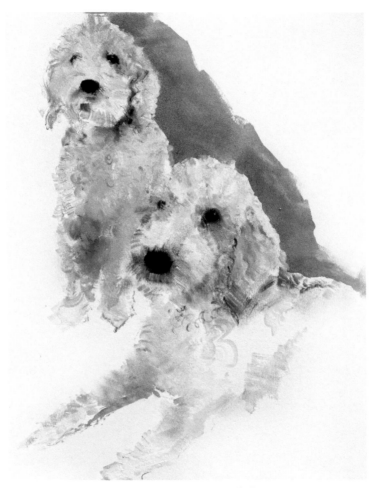

Dusty and Nutty, fluffy and indolent Bedlingtons

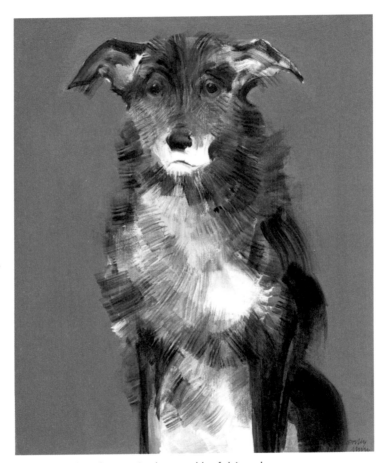

Fluke, a Milan hound, great city dog, capable of doing solo
trips to the bar; always greeted visitors with a little gift

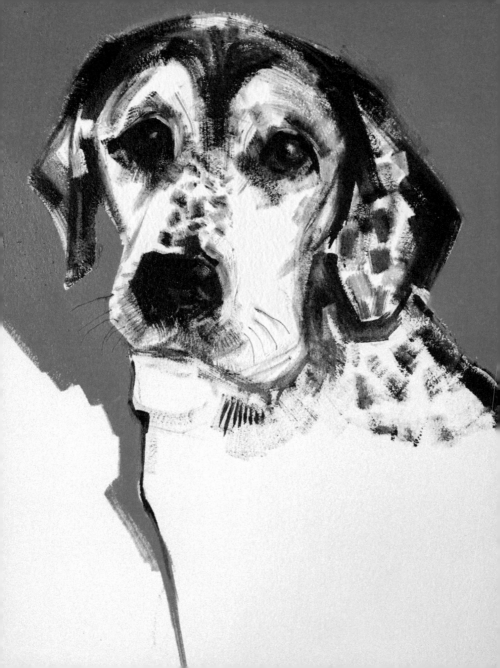

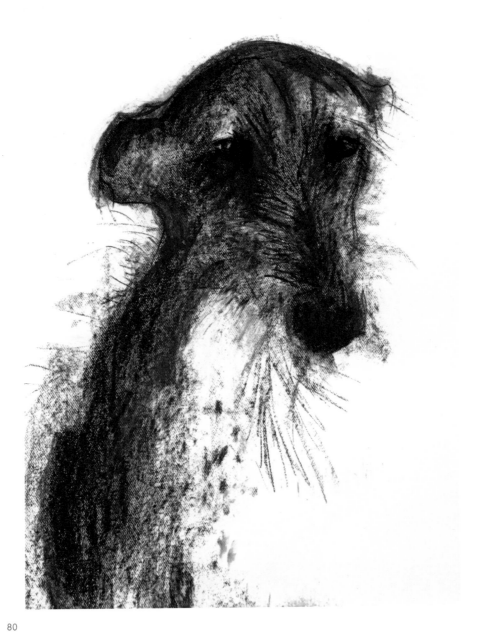

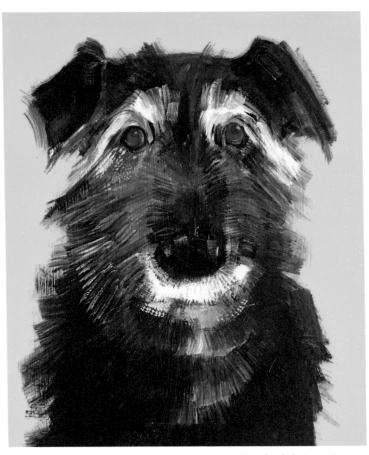

Mac, lovely hairy terrier cross

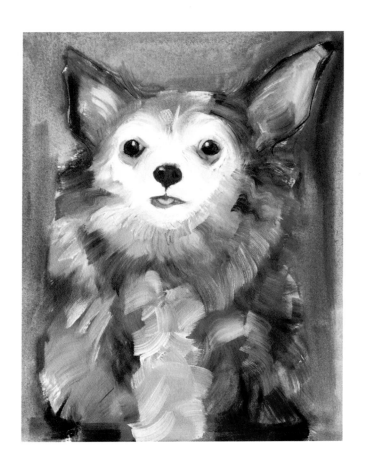

Beloved tiny rescue Chihuaha, Englebert – a fashion icon and Instagram star

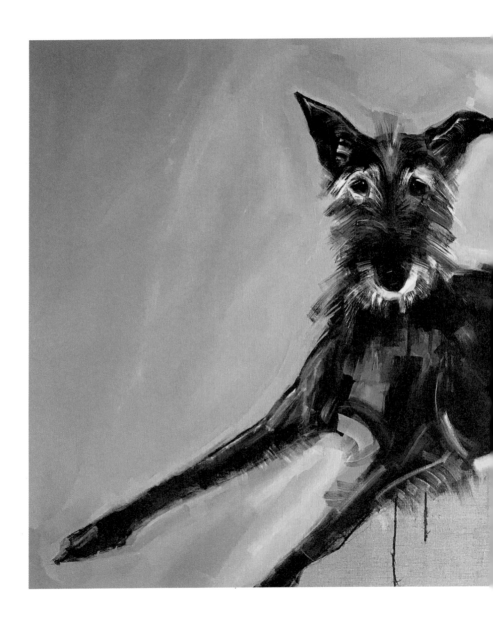

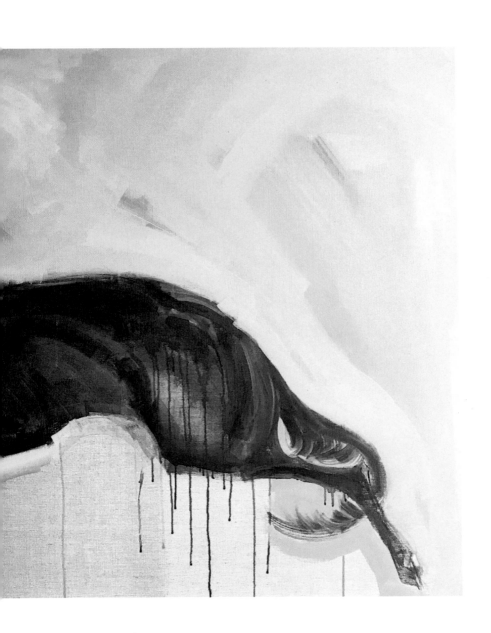

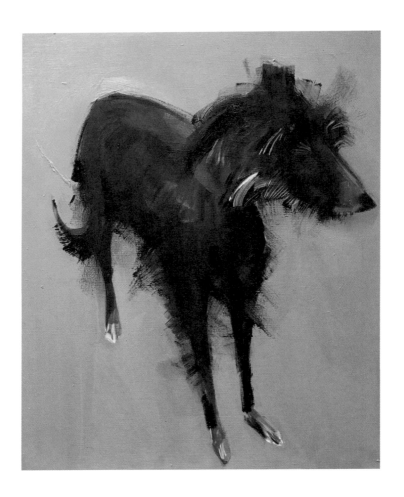

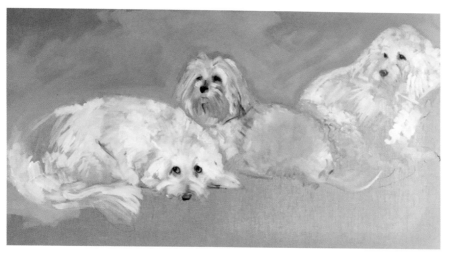

Lewis, Hetty and Betty, charming collection of elderly rescues, enjoying their sofa

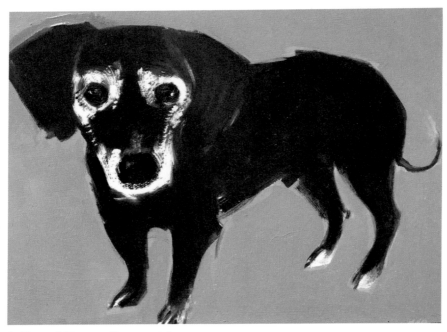

Archie aged 18 — saw off many a delivery man

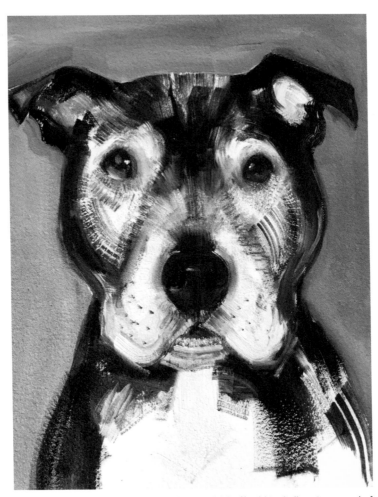

Moose, a 12-year-old Staffordshire bull terrier, scared of cats and terrorized by both his owner's ferret and puppy

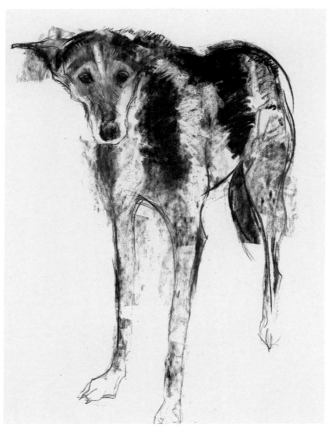

Dino, beautiful and unusually speckled spotty lurcher – bit wobbly on his legs

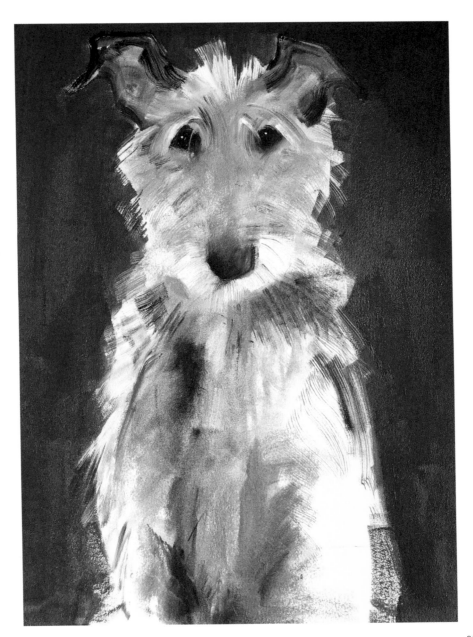

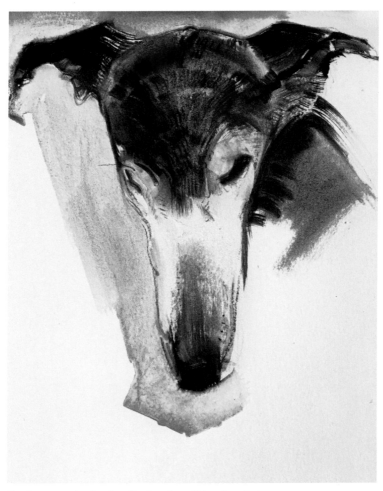

Gordon, rescued galgo from Spain, a beautiful and gentle boy

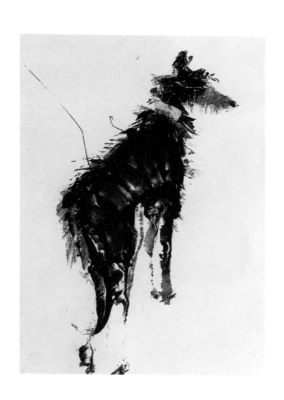

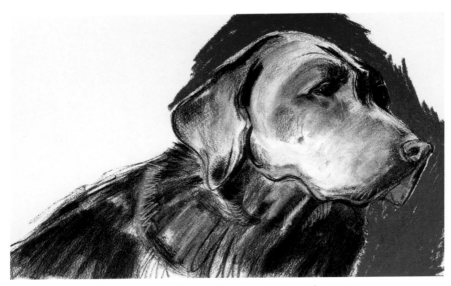

Casey, smart as a whip, loving and loyal – her tail almost never stopped wagging

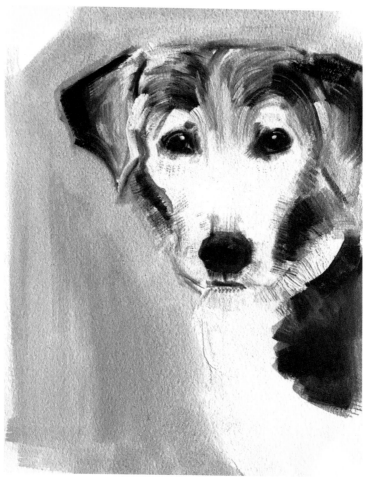

Audrey, beautiful limpy lurcher, one leg shorter than the others, adopted aged 10

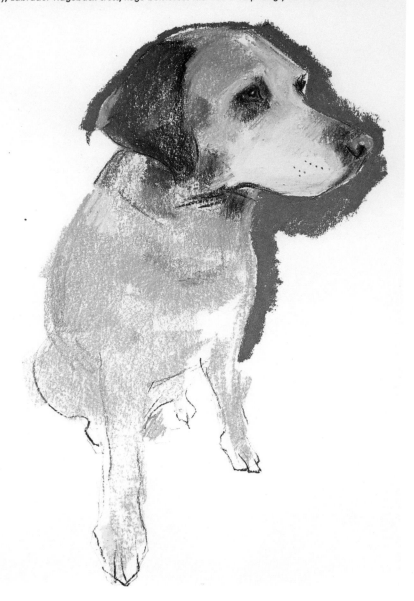

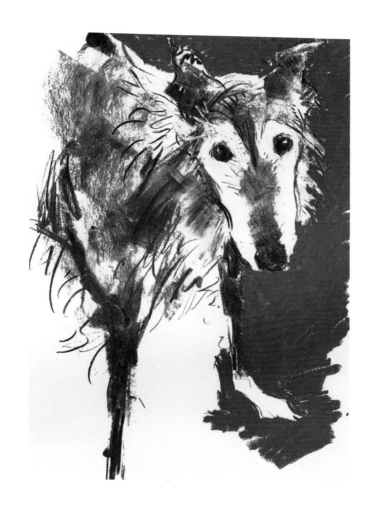

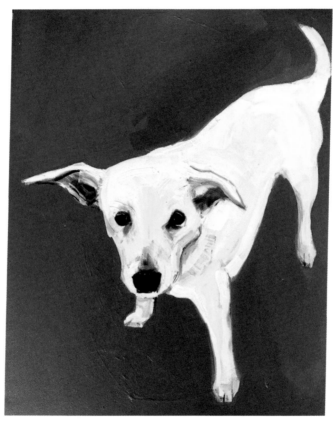

Missy, the third child that didn't argue back, never
complained and travelled in a bicycle basket all her life

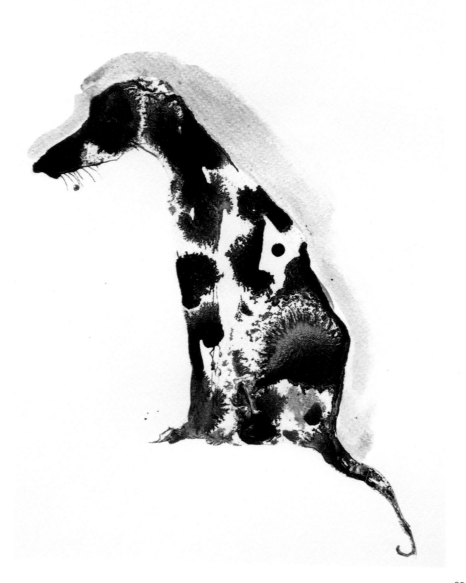

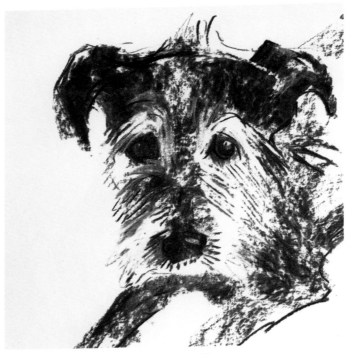

Nelson, very distinguished and head-turning in his senior years

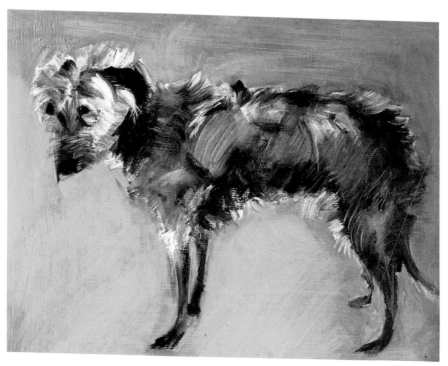

Beautiful, fragile lurcher, Perdita

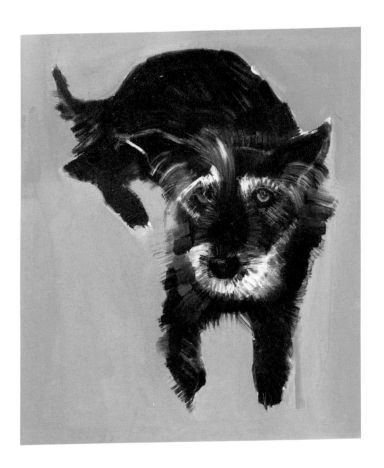

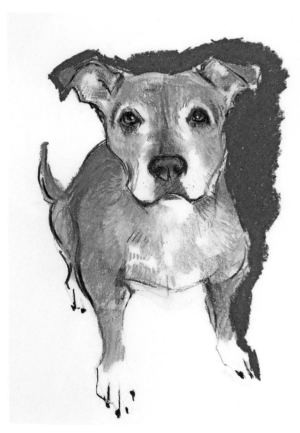

Lola, gorgeous Staffie cross, aged 12

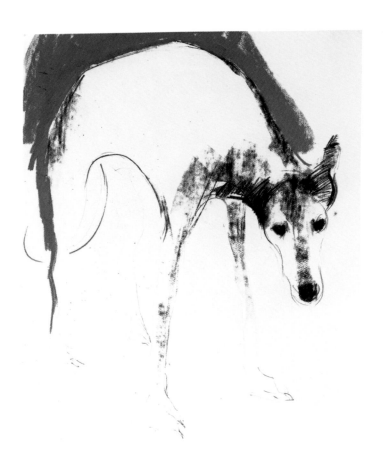

Ghostly Lily in her winter coat

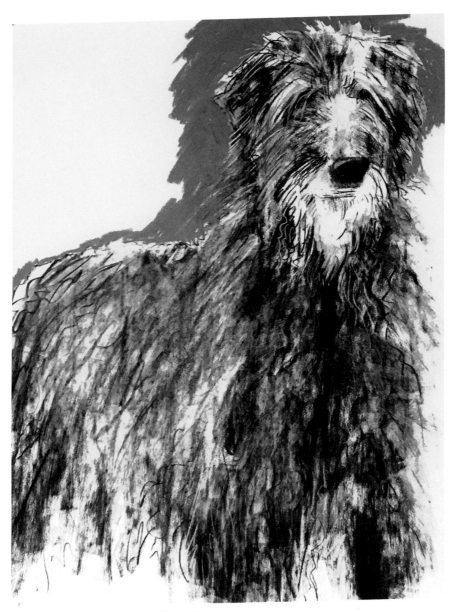

Elgar, absolutely huge wolfhound with terrific goatee

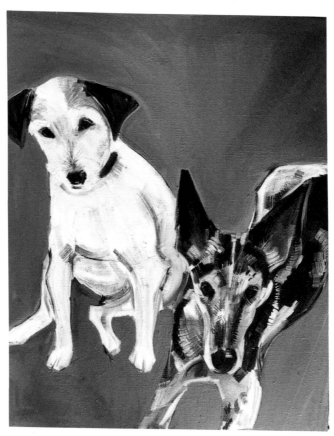

Biff and Dino, elderly friends, mellowed with age

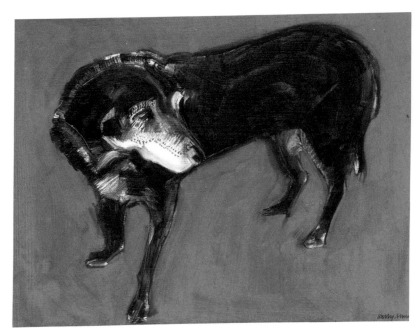

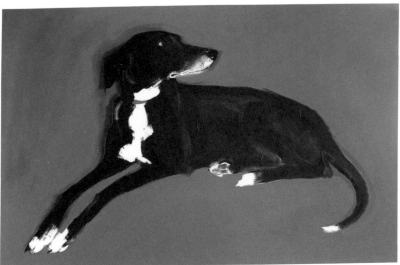

Bottom: Layla a girl of firm opinions but lovely when you get to know her, friend to my whippets

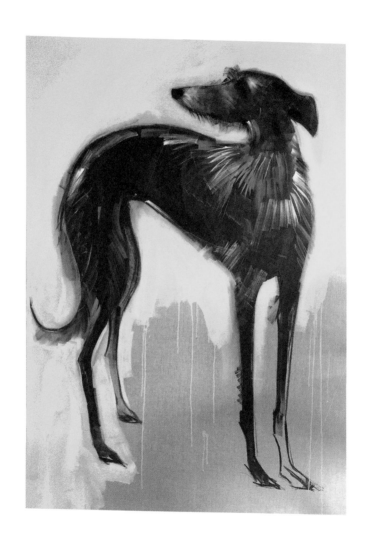

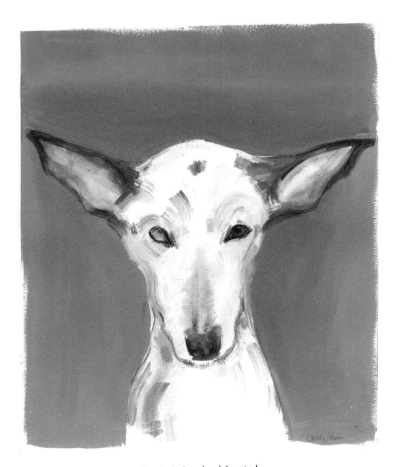

Grannypants, fabulously single-minded and opinionated
poster girl of Galgos del Sol dog rescue

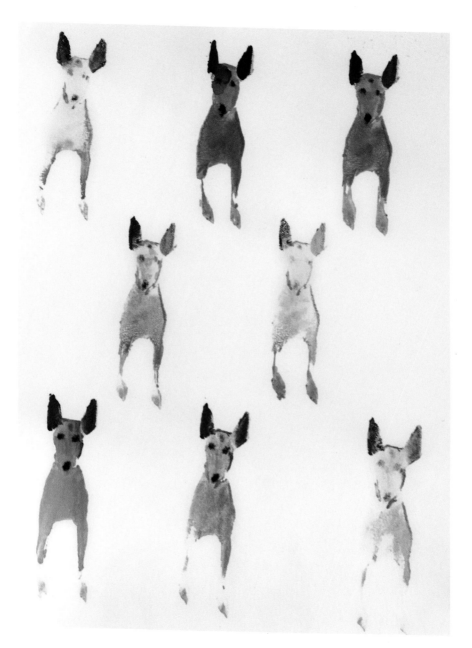

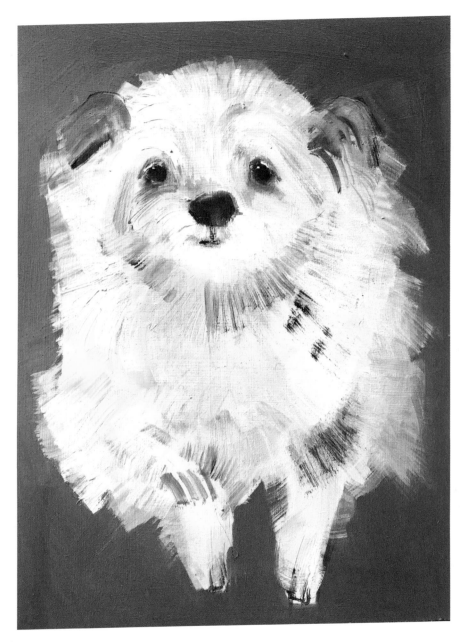

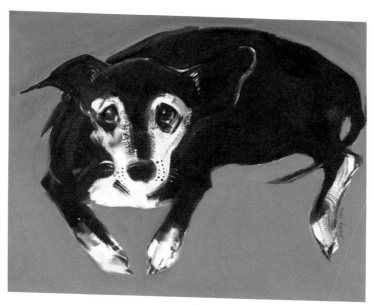

Diesel, aged 18½ , the sweetest soul ever

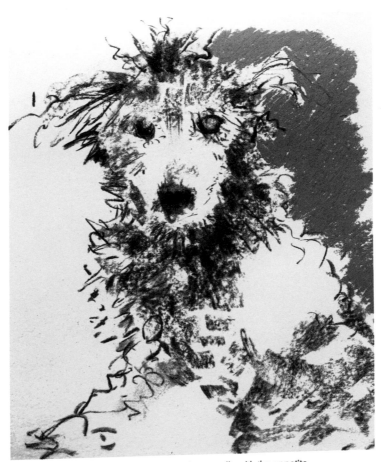

Doris one of Wolfgang's elderly rescue pack, a poodle with the appetite
of a Great Dane

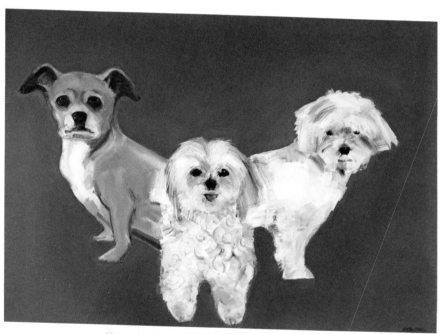

Honey, Barkley and Mia, beloved rescues now starring on their own wine label

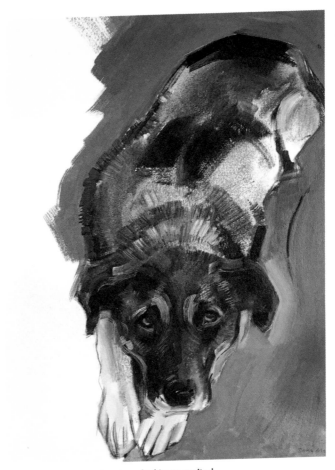

Potter, classic rescue — treats make him so excited
that he bounds joyfully out of the room

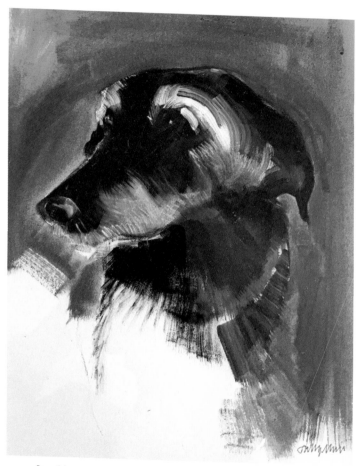

Bramble, owner of the most gorgeous eyebrows and lovely grey facial hair

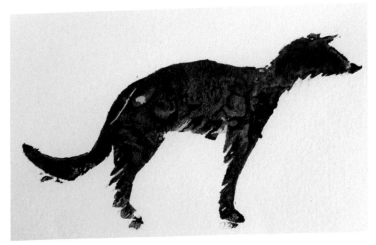

Nell in potato print form

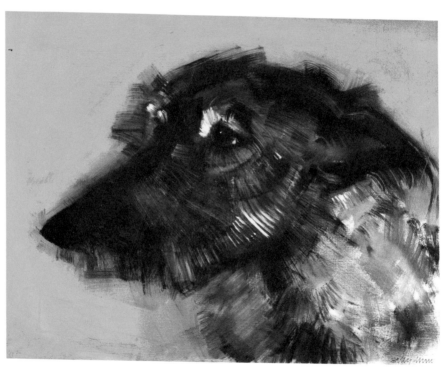

Gabriel, 13-year-old rescue lurcher

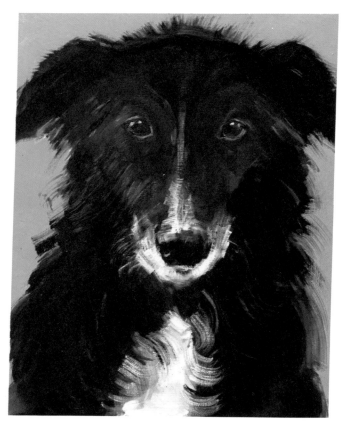

Rosie, beautiful and clever border collie

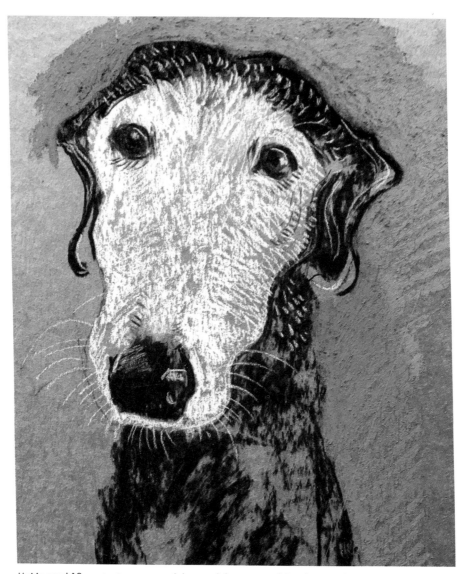

Maisie aged 13, mentor to nervous and damaged dogs – as confident, bossy and sassy as she's always been

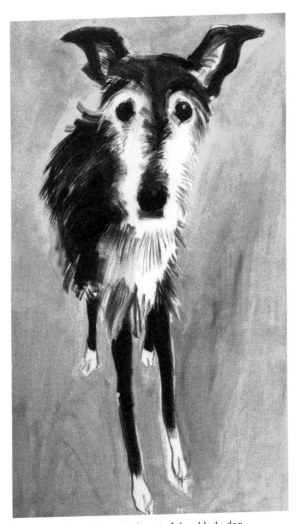

Jet, for me the perfect embodiment of the elderly dog

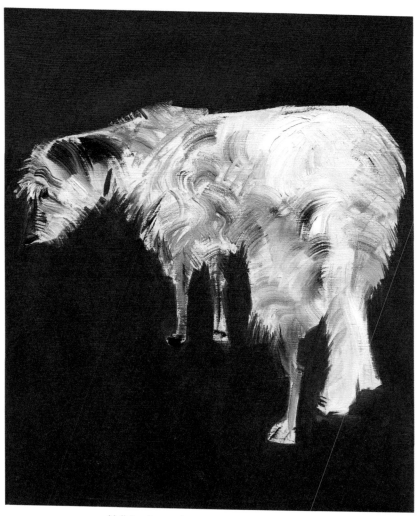

Nell, loveliest and most charming Bedlington-whippet lurcher, lived to 17

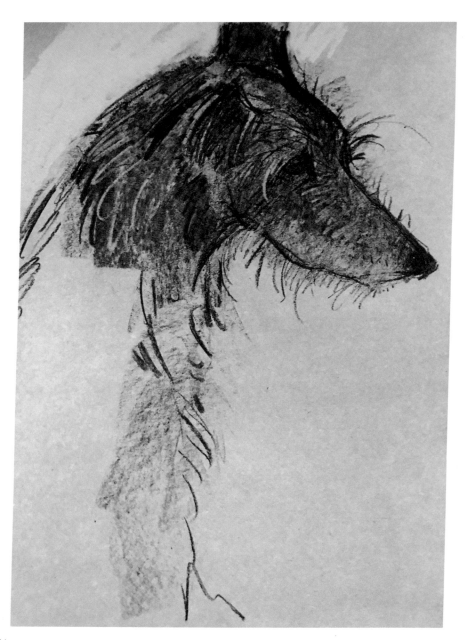

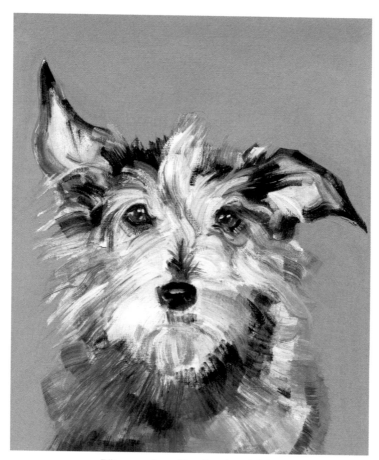

Tillie, marvellous old terrier mix with fabulously expressive ears

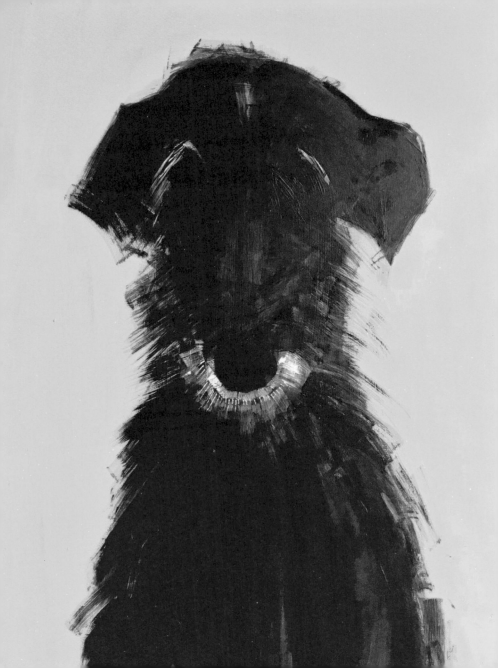

Thank you very much to everyone who responded to my call out for photos of their old dogs, I loved seeing them all and reading about them. I'm sorry that I haven't managed to paint every single one of them, I only wish I could. I've tried my best to remember every dog's name, but please forgive me if I've failed.

Thank you also to Pavilion: Polly, Katie, and Helen for commissioning another book, I can't believe my luck, and to Alice and Izzy for all their work and being very, very patient with me.

First published in the United Kingdom in 2021 by
Pavilion
43 Great Ormond Street
London
WC1N 3HZ

ISBN 978-1-911663-19-5

A CIP catalogue record for this book is available from the British Library.

10 9 8 7 6 5 4 3 2 1

Reproduction by Rival Colour Limited, UK
Printed and bound by 1010 Printing International, China

www.pavilionbooks.com

Publisher: Helen Lewis
Editor: Izzy Holton
Designer: Alice Kennedy-Owen
Production Controller: Phil Brown

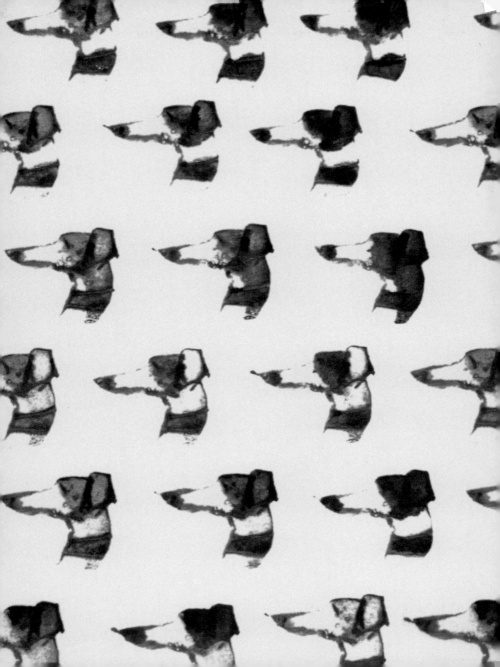